W9-BAZ-313

 Dillon Gallery Press

Cover: Girl with Raven, oil on canvas, 50" x 40"

Photography: Edward Gorn

ISBN:1-930372-00-0

Copyright © 2000 Alexander Kaletski

Printed in Korea

Design and Production: Valerie Dillon and Eric Iversen

ALEXANDER KALETSKI

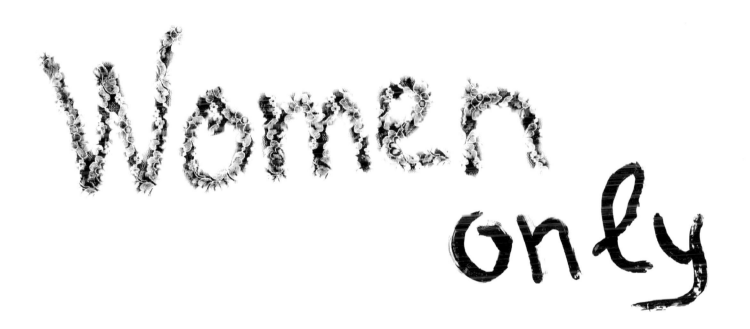

Women only

DILLON GALLERY
431 WEST BROADWAY, NEW YORK, NY 10012 (212) 966-2977

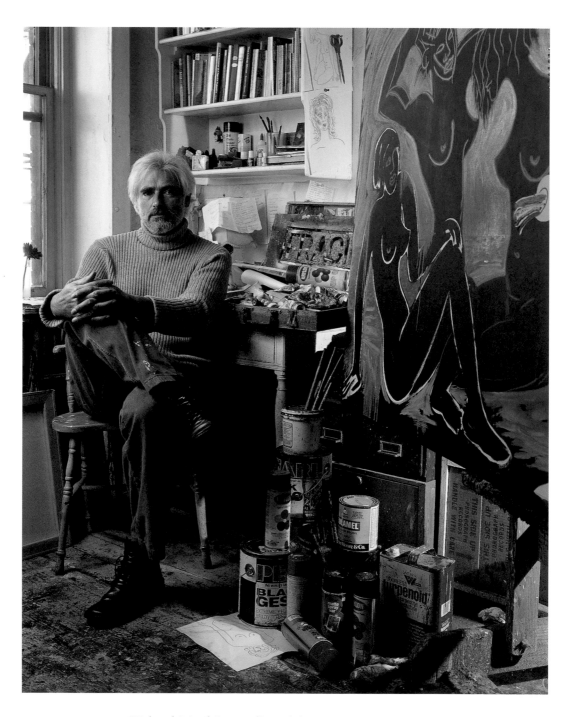

Kaletski in his studio with *Girls at the Sea*.

I miss your kiss,
 your lips,
 your tongue,
 your breath,
 and all your smiling mouth, which gave me
 such a joy in such a little time.

I miss your eyes as cold as early ice,
 your heavy eyelids,
 your distant look,
 your wavy, silky hair,
 your arching neck,
 your back,
 your round buttocks,
 your breasts,
 your nipples, pink and tender, standing up.

I miss your hug,
 your touch as delicate and firm as the touch of
 fate,
 your weightless arms,
 your searching hands,
 your fingers dry and thin,
 your nails which scratched me once,
 your palms with endless lines of mystery and
 lust,
 your past and distant future.

I miss your lovely face,
 the color of your cheeks in heat,
 the salt of tears running down,
 the bitter taste of armpits,
 the scent of secret nectar...

I miss you all, but most of all your soul.

 A.K.

FRUIT BASKET 48" x 38"
oil on canvas

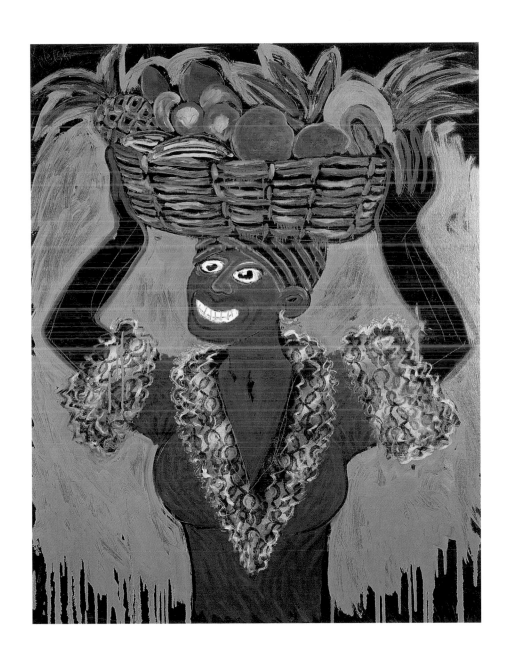

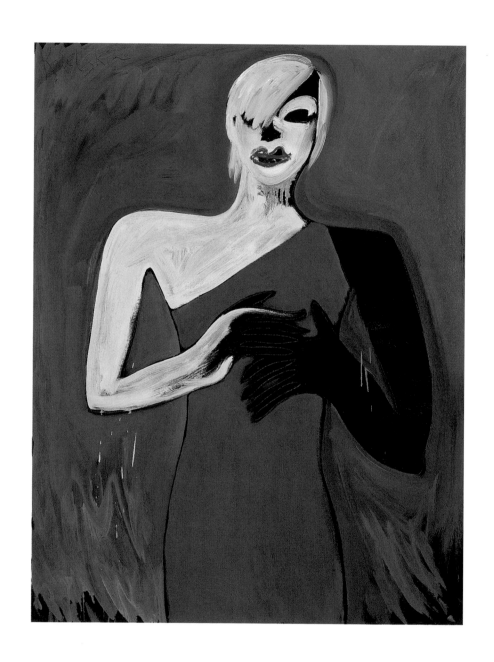

RED HOT 50" x 38"
oil on canvas

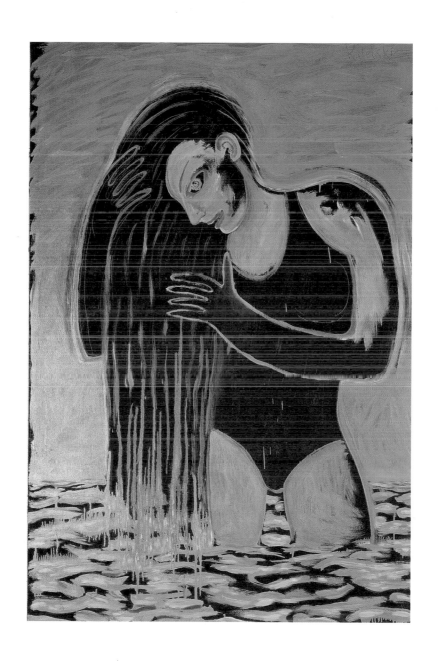

WET HAIR 60" x 40"
oil on canvas

SCRAMBLED EGGS 60" x 48"
oil on canvas

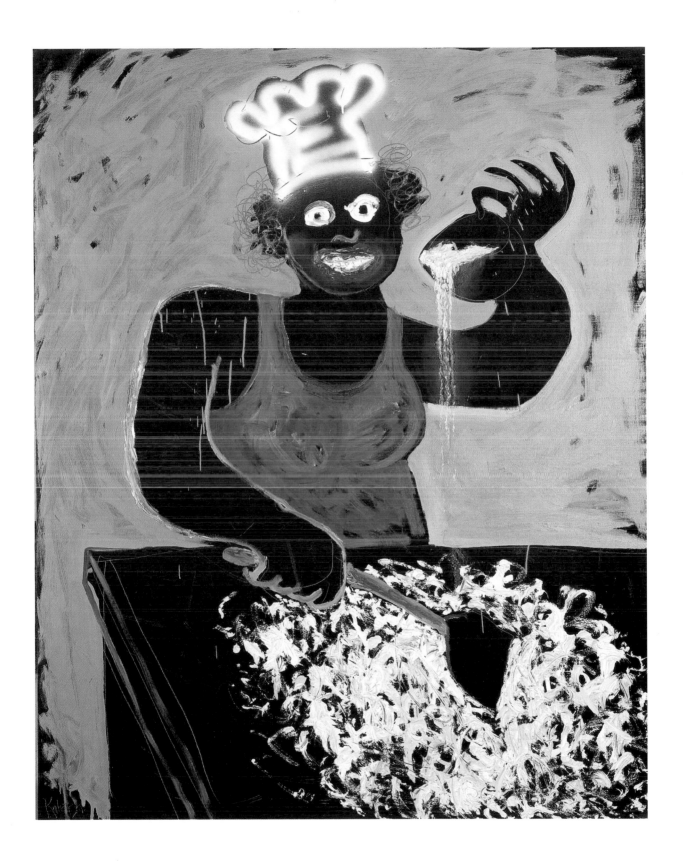

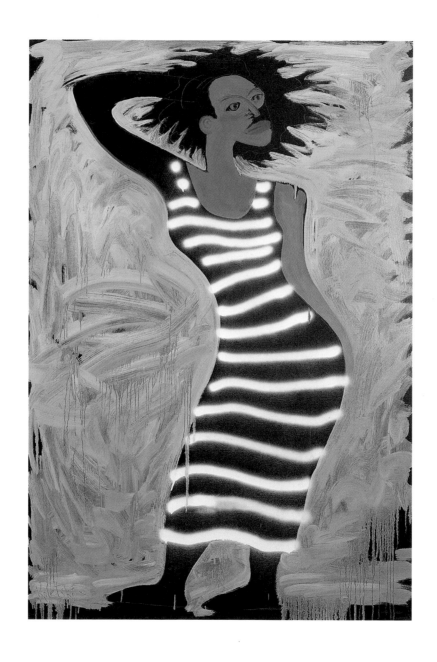

BEACH WITCH 60" x 40"
oil on canvas

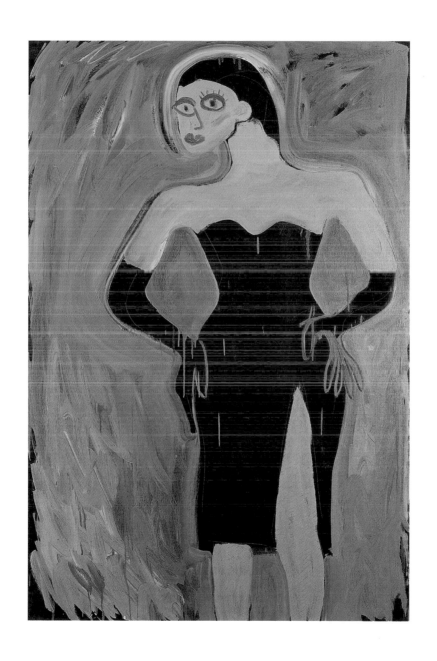

HIGH THIGH 60" x 40"
oil on canvas

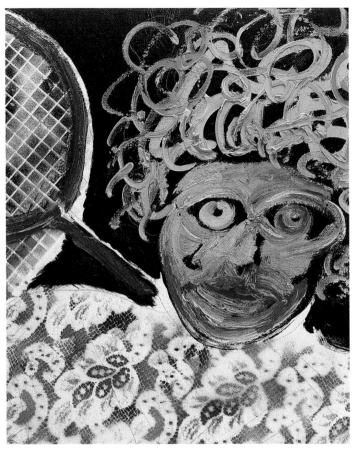

detail

HUNTRESS 60" x 48"
oil on canvas

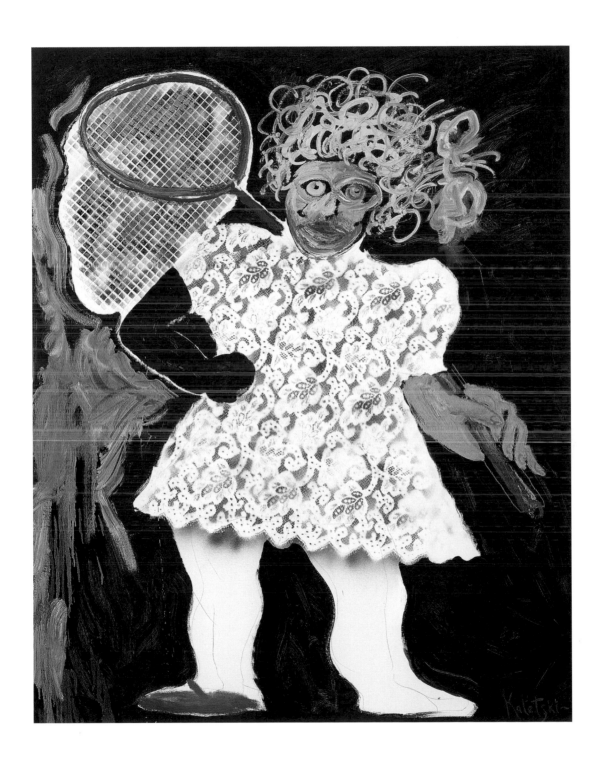

LADY GODIVA 62" x 46"
oil on canvas

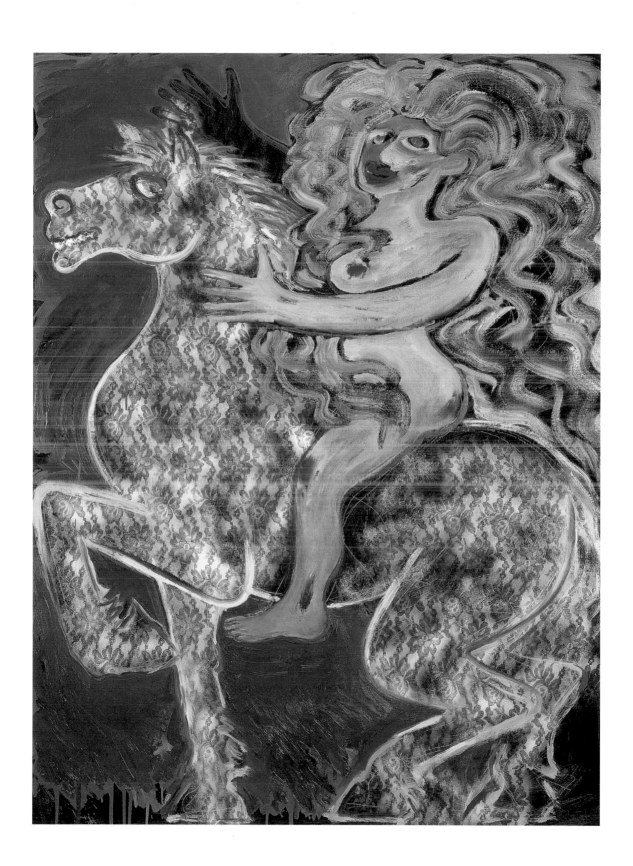

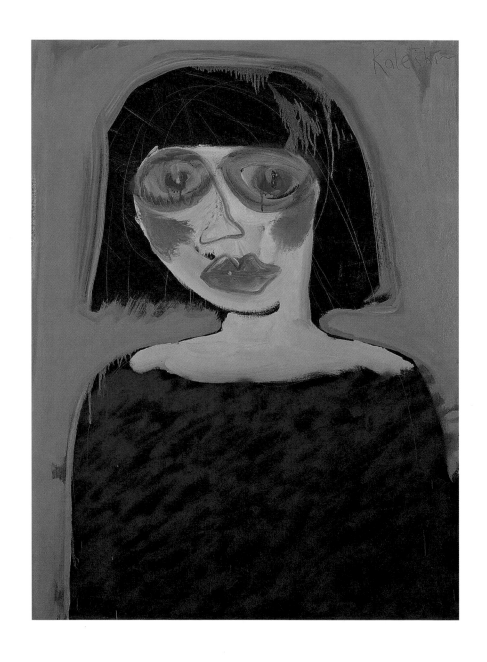

GREEN EYES 48" x 36"
oil on canvas

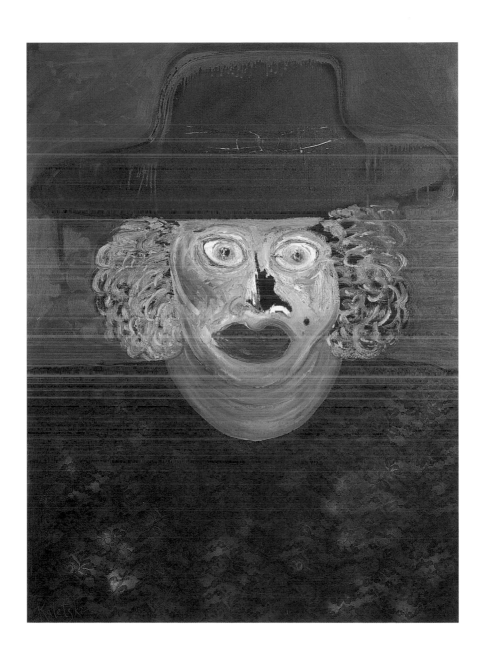

RED HAT 48” x 36”
oil on canvas

VIRGIN QUEEN 62" x 46"
oil on canvas

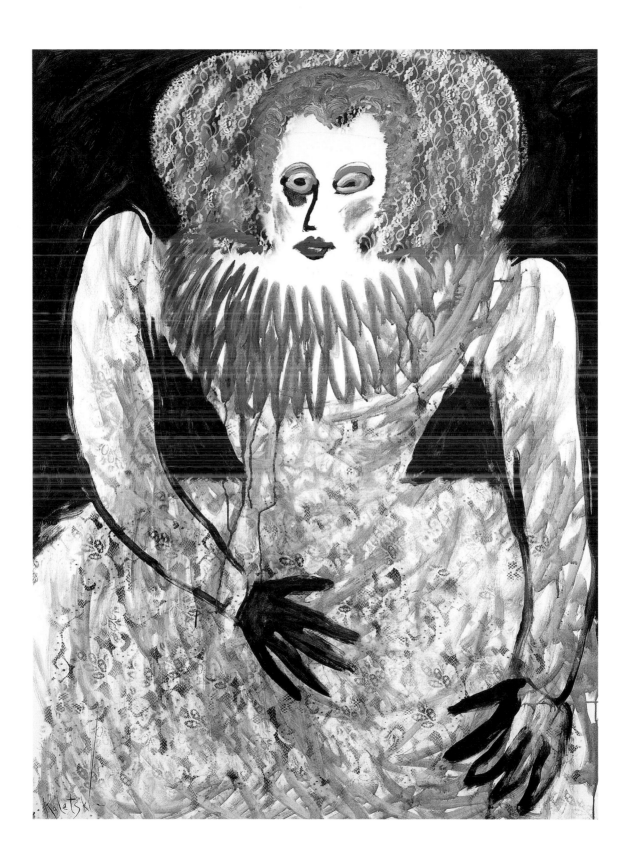

TEA CEREMONY 60" x 48"
oil on canvas

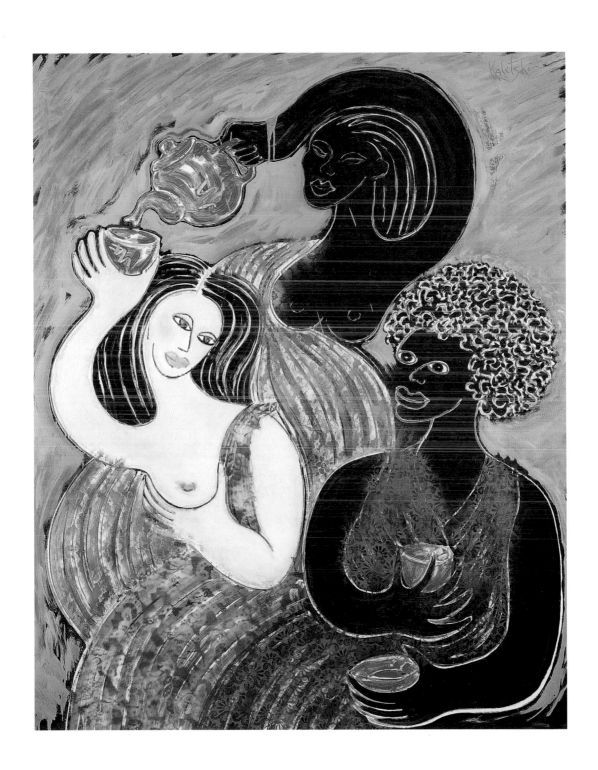

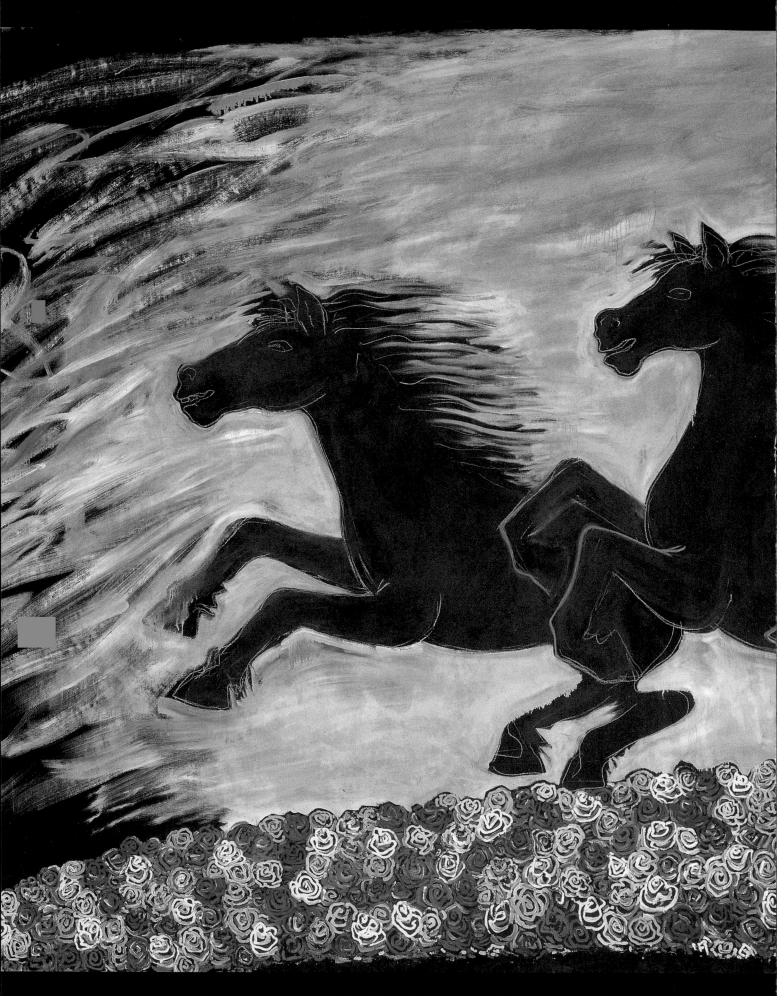

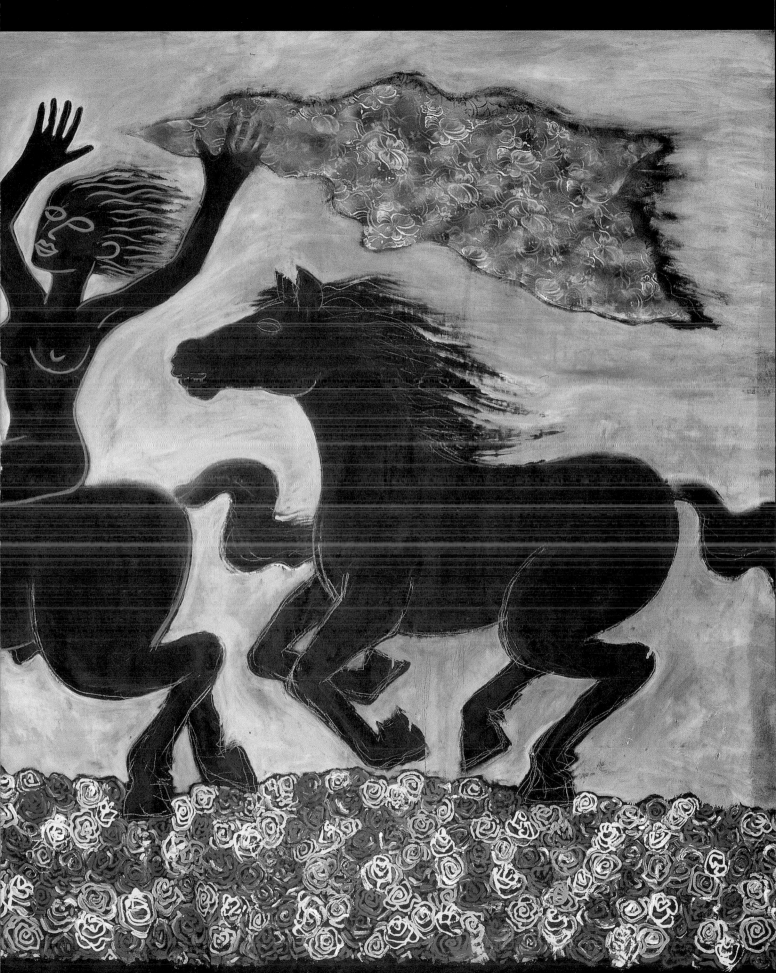

previous page
TWILIGHT RIDE 86" x 186"
oil on canvas

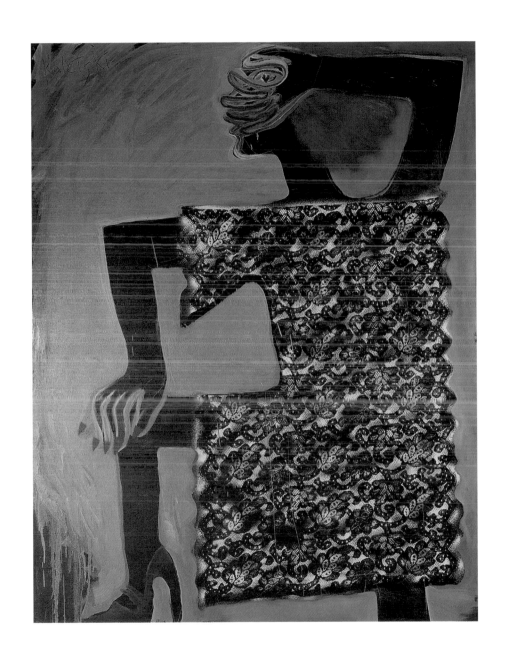

READY, STEADY, GO ! 62" x 48"
oil on canvas

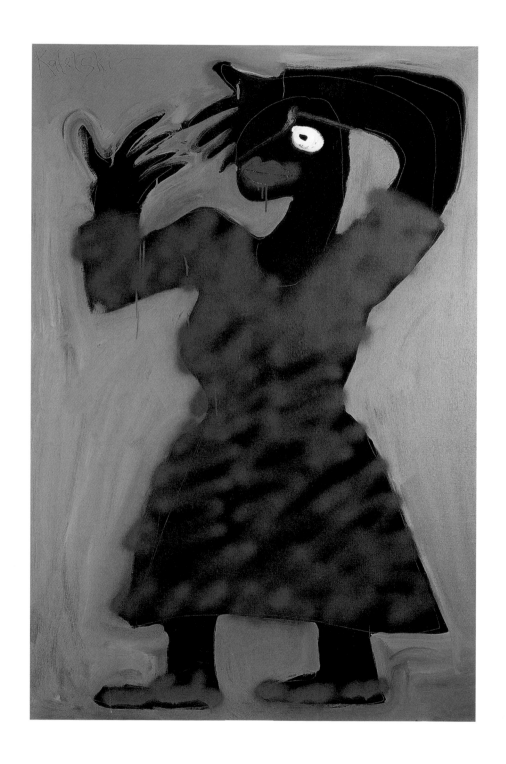

AND SHOES TO MATCH 60" x 40"
oil on canvas

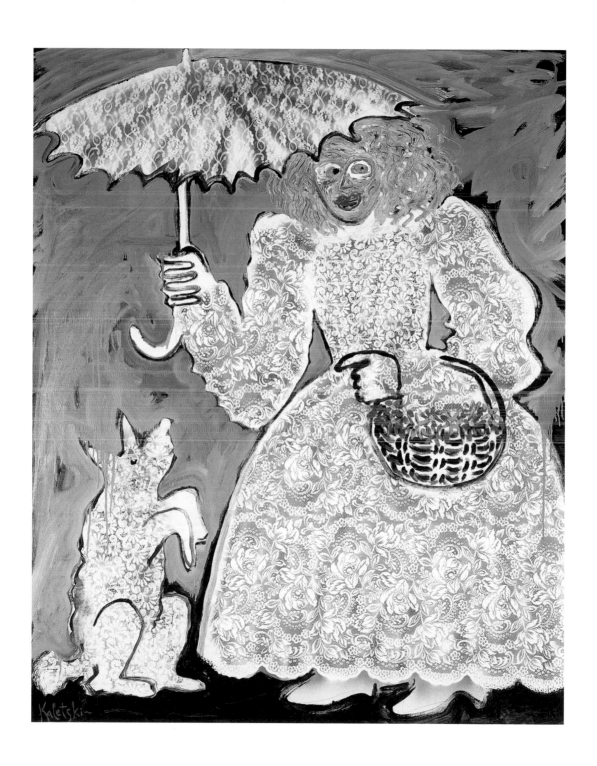

LACY 60" x 48"
oil on canvas

BLACK, WHITE AND BLUE 50" x 60"
oil on canvas

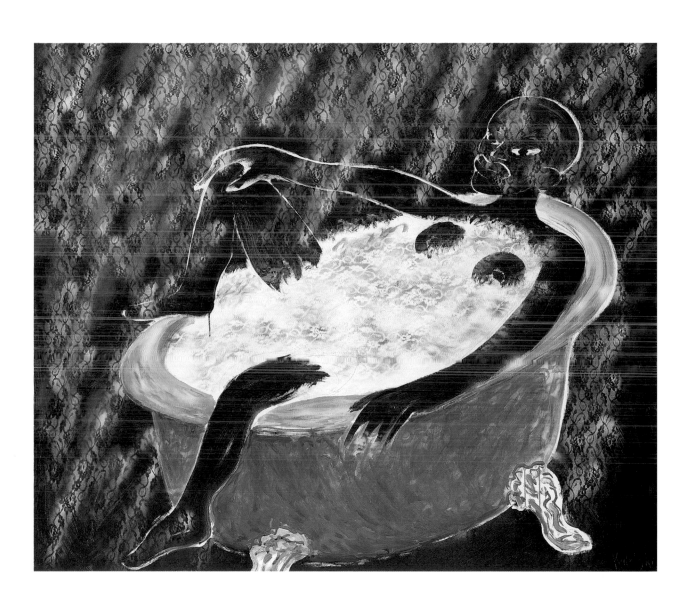

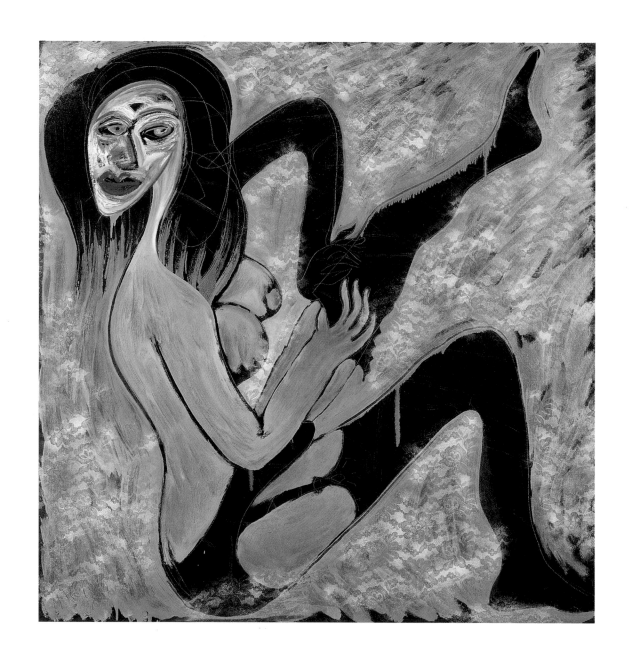

BLACK STOCKINGS 50" x 48"
oil on canvas

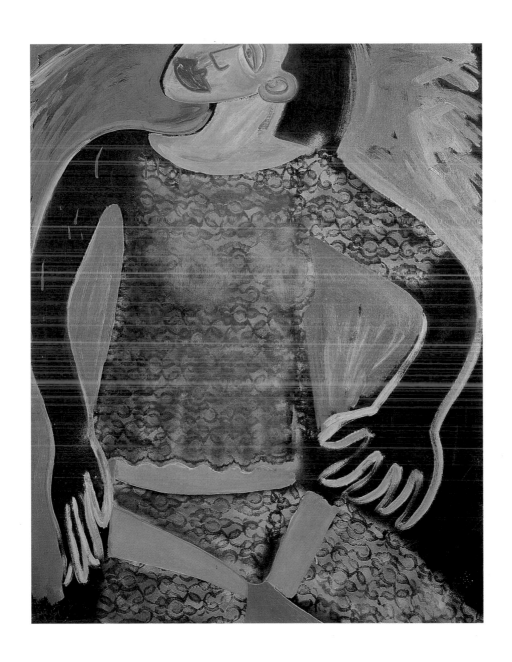

LINGERIE 48" x 38"
oil on canvas

DANCE LESSON 60" x 48"
oil on canvas

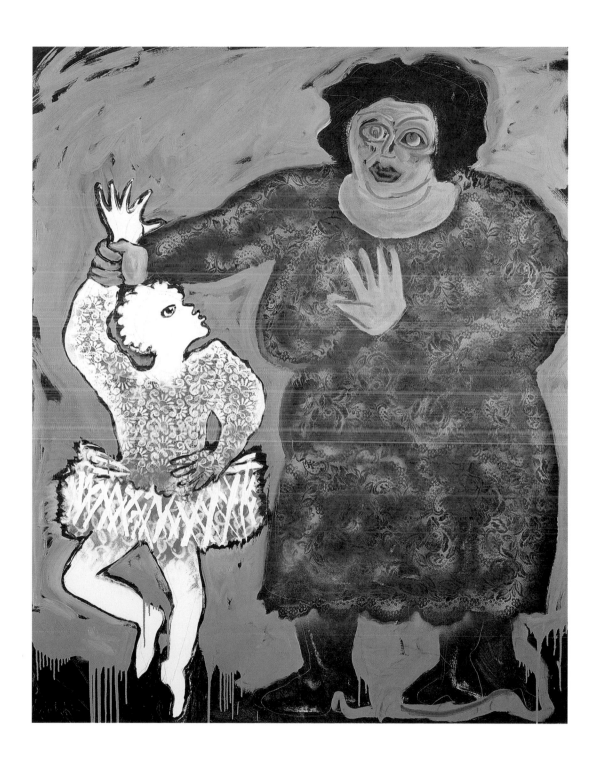

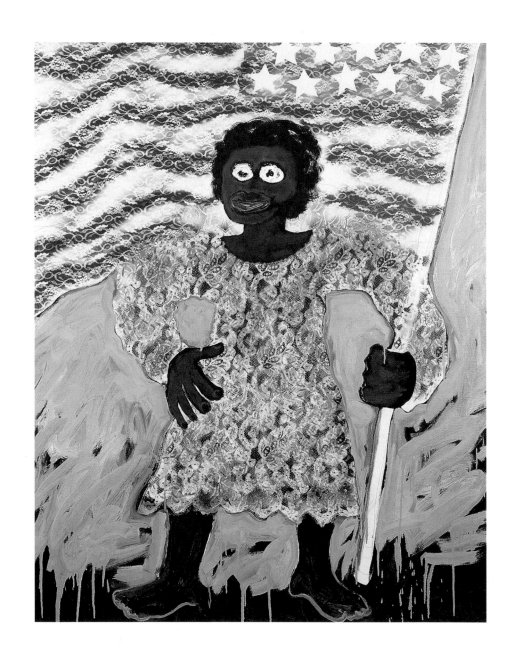

YOUNG GLORY 60" x 48"
oil on canvas

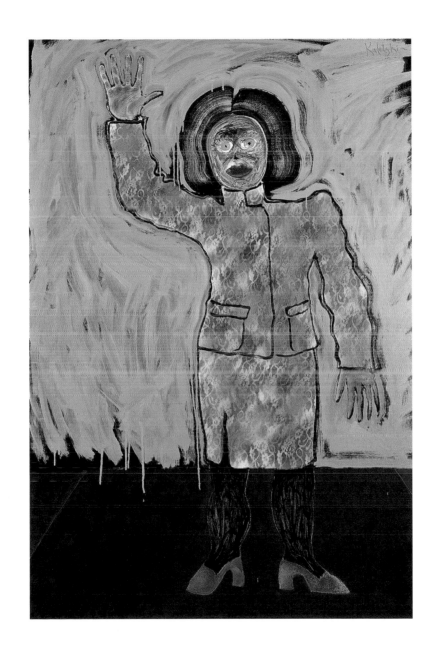

ALMOST FIRST LADY 60" x 40"
oil on canvas

BLACK PUSSY 58" x 40"
oil on canvas

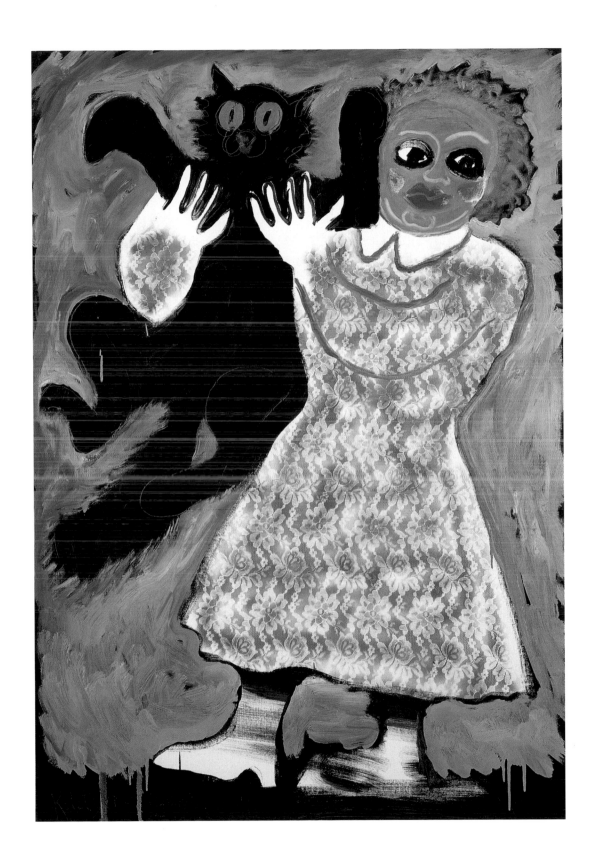

MOTHERHOOD 50" x 34"
oil on canvas

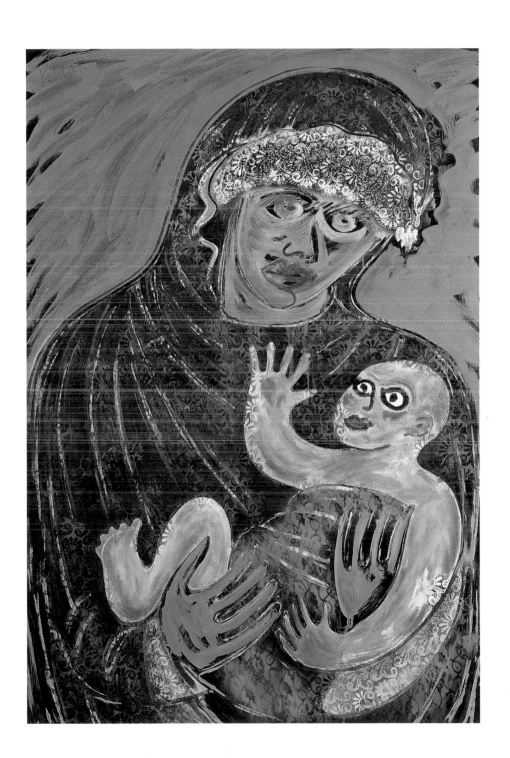

SOLO EXHIBITIONS

2000	"Women Only" Dillon Gallery, New York, NY
1999	"Paper Heroes" Modern Art Museum of Belarus, Minsk, Belarus
1998	"Wallpaper Heroes" Dillon Gallery, New York, NY
1997	"Nude Colony" Dillon Gallery, New York, NY
1996	"Cardboard People" Dillon Gallery, New York, NY
1996	"Split Personality" Gwenda Jay Gallery, Chicago, IL
1995	"Dead Ancestors" Dillon Gallery, New York
1994	"Dreams of a Window Cleaner" Dillon Gallery, New York, NY
1993	"People in Boxes" Z Gallery, New York, NY
1989	"Rectangles of Fate" Andre Zarre Gallery, New York, NY
1987	"Angular People" Schiller-Wapner Gallery, New York, NY
1977	Princeton University, Princeton, NJ
1976	Indiana University, Bloomington, IN
1976	Columbia University, New York, NY
1975	Saratoga Art Center, Saratoga, NY

GROUP EXHIBITIONS

1999	"Fifth Annual Invitational Exhibition" Dillon Gallery, New York, NY
1998	"Self-Portrait" Caldic Collection, Rotterdam, Netherlands
1998	"Summer Group Exhibition" Dillon Gallery, New York, NY
1997	"Black or White" Dillon Gallery, New York, NY
1996	"Past-Post" Dillon Gallery, New York, NY
1995	"Flowers, NYC" Dillon Gallery, New York, NY
1992	Alex Edmund Gallery, New York, NY
1991	Z Gallery, New York, NY

BIBLIOGRAPHY

METRO: A Novel of the Moscow Underground; A. Kaletski, Viking Press, 1985
WOMEN ONLY; A. Kaletski, Dillon Gallery Press, 2000
WALLPAPER HEROES; A. Kaletski, Dillon Gallery Press, 1998
NUDE COLONY; A. Kaletski, Dillon Gallery Press, 1997
CARDBOARD PEOPLE; A. Kaletski, Dillon Gallery Press, 1996
DEAD ANCESTORS; A. Kaletski, Dillon Gallery Press, 1995

BELARUS TODAY, "Paradise Lost?" July 1999
GLORY OF THE MOTHER LAND, "Cardboard People from New York," July 1999
WALLS, WINDOWS AND FLOORS, "Up Close and Personal," June 1999
LDB INTERIOR TEXTILES, "On the Edge: Wallpaper Heroes," October 1998
THE VILLAGER, "Russian artist reads it in the 'papers'," September 30, 1998
COVER MAGAZINE, Volume 12, Number 5, October 1998
GALLERY GUIDE, November, 1997
ART NEWS, "Reviews," February 1997
THE VILLAGER, "A Russian Explorer Tests American Freedoms," October 2, 1996
COVER MAGAZINE, October 1996
ASSOCIATED PRESS, "Out from the Underground," September 1996
GALLERY GUIDE, September 1996
GALLERY GUIDE, April 1996
HARPERS MAGAZINE, December 1995
THE ECONOMIST, September 1995
GALLERY GUIDE, Downtown Preview, September 1995
FRANKFURT ALGEMEINE, August 19, 1995
LA LIBRE BELGIQUE "Les multiples vies D' Alexander Kaletski", March 28, 1989
MANHATTAN, "From Russia with Love", 1988
MANHATTAN, "Art in America", 1988
HONEY, London, October 1985
THE SUNDAY TRIBUNE, "Metro Man", October 27, 1985
MIDWEEK, "Red Alert", October 3, 1985
THE IRISH TIMES, "Beating the System", September 7, 1985
DAILY MAIL LONDON, "Durrant's", September 3, 1985
NEWSDAY, "From a Russian with Love", June 12, 1985
INTERNATIONAL HERALD TRIBUNE, "From Soviet Gray to Manhattan Glitter", June 5, 1985
THE WASHINGTON POST, "Steps of an Emigre" May 29, 1985
CHRISTIAN SCIENCE MONITOR, "Novel of Soviet Underground is Great Bear-Hug of a Book", May 29, 1985
THE WASHINGTON POST, "Style: Out of the Underground", May 29, 1985

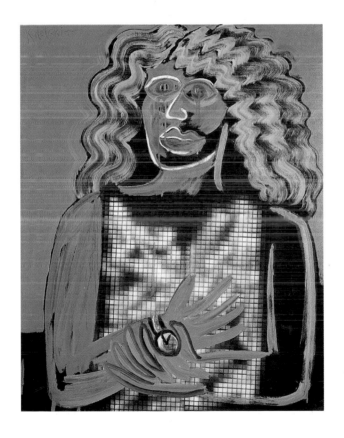

UNTIL NEXT TIME 50" x 40"
oil on canvas